Executive Editor/Seiji Horibuchi
Associate Editor/Yuki Inoue
Book Design/Shinji Horibuchi
Publisher/Masahiro Oga

Distributed to the book trade by Publishers Group West.

Printed in Japan

This volume is a newly edited English edition of
CG STEREOGRAM 3, published by Shogakukan Inc.
in Tokyo, Japan. Original edition edited by
Tsuneo Nemoto, Masaki Tokuyama and
Noburo Tsukahara.

ISBN 1-56931-025-4

First Printing, June 1994
10 9 8 7 6 5 4 3 2 1

Cadence Books
A Division of Viz Communications Inc.
P.O. Box 77010
San Francisco, California 94107

SUPERSTEREOGRAM

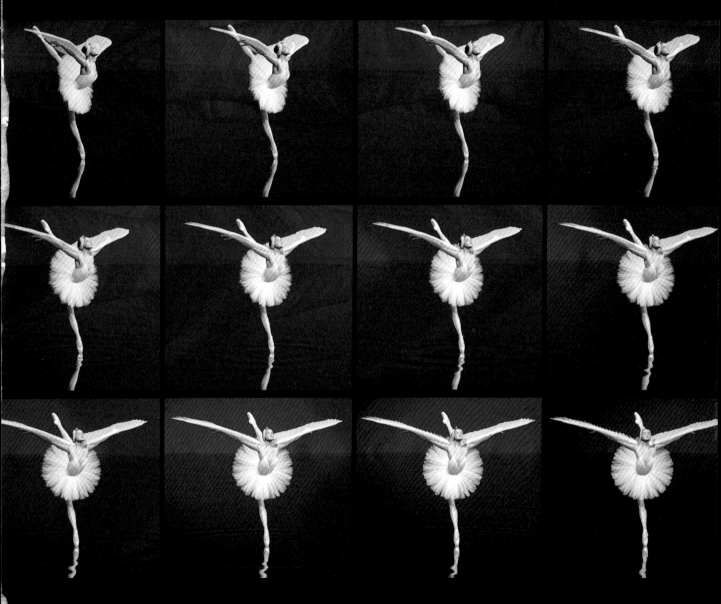

CADENCE BOOKS SAN FRANCISCO

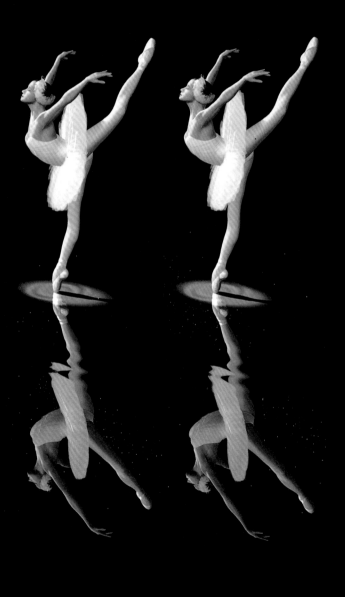

**Swan Lake
(Cecile Dancing in My Dreams)**
Seiji Yoshimoto

*The images on this and the pre-
ceding page are not photographs,
but three-dimensional computer
images which took three years
to produce.*

Contents

Jacket Artwork(Front)/DIN
Jacket Artwork(Back)/
Shiro Nakayama
Cover Artwork/Hiroshi Kunoh
End Paper Artwork/
Shiro Nakayama

A New 3-D Fraternity and Rebirth/ Resurgence

David Burder

The phenomenal success of the initial *Stereogram* publication has resulted in the demand for a worthy successor. To satisfy this demand, I am delighted to introduce this new edition, which features the works of many international 3-D artists and shows the very latest 3-D techniques and styles. This book is a true visual experience.

I find it amazing that a completely new art cult has grown around a technique that requires people to make their eyes perform feats for which they were never intended. Ten years ago, I considered myself fortunate, and certainly in a tiny minority, in being able to view stereo pairs of images without any special 3-D viewer. I would never have believed that books which relied upon people being able to achieve this feat would become bestsellers.

I find it amazing that a completely

new art cult
has grown around a technique.

So, I was wrong, and as a result of this 3-D craze, the original *Stereogram* book has been reprinted and published worldwide and has created the need for a new edition.

Several catchwords are associated with the phenomenon and may

be worth explaining now because they keep appearing whenever the process is discussed. "Stereogram" just refers to the picture itself, whether or not you have managed to see it in 3-D. "Fusion" is the art of being able to see it in three dimensions. "Dotty gram" is my informal description of the type of picture (the random-dot stereogram) that appears as a single picture for "automatically" viewing in 3-D, rather than being presented as two pictures that require a special 3-D viewer. Besides the dotty gram, this book contains other examples of 3-D such as "stereo wallpaper," which are described later.

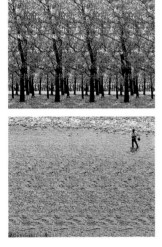

The origins of today's craze are directly attributable to Bela Julesz's work in the late 1950s and the 1960s. Among my treasured 3-D possessions is his book *The Foundations of Cyclopean Perception*, in which he introduced the concept of computer-generated, random-dot stereograms. These were in the form of stereo pairs and red/green anaglyphs. Indeed, I still use his examples in my lectures to students on stereoscopic perception. Christopher Tyler and Maureen Clarke are responsible for having developed Julesz's initial concept into the "single-image" autostereogram technique that has created its mass popularity. Others, notably Harold Thimbleby, further refined the process, while other artists have developed new techniques altogether.

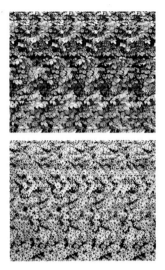

Although the phenomenon has achieved popularity through enjoyment and entertainment, we must not forget that its origins were in the quest for understanding the routes of human visual perception, as investigated by Julesz, Gregory, Gombich, Heard, and other scientists. The process has progressed in leaps and bounds, as more artists have developed their own styles and techniques. The earliest examples consisted only of random dots, in black and white, and were not always easy to view, but the latest examples are often beautiful even when viewed with just one eye. I still derive the greatest excitement in anticipating what magic is about to happen when I meet a new stereogram waiting to be experienced. Will I even be able to achieve fusion? Will it be instant and obvious, or will it slowly draw me into the picture as I explore around it, discovering subtle shapes and forms lurking to be revealed? And how will it look if I cross my eyes rather than stare straight ahead in order to fuse the image? (Instructions for fusing, or parallel techniques, are included elsewhere in this book.)

Most people do need the encouragement of a friend, or at least to be prepared to spare some time in training themselves to first be able to see stereograms. Thereafter, it certainly does become easier every time one achieves success. However, it is not

really like riding a bicycle. I find that even experi-
enced people may need a few moments to
achieve fusion of each image, and some images
do require a lot more concentration and effort
than others. The pleasure of sharing the experi-
ence with other people must surely be the most
rewarding part of the process. I only hope that
those who do have problems will persevere
through the encouragement of others, so they
can finally succeed in achieving the magical
effects.

**The pleasure of sharing the experience with
other people must surely be the**

most rewarding part of the process.

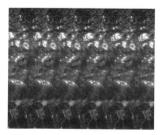

Random-dot stereograms (which I also refer to as dotty grams) are
the examples that started the craze. However,
several other techniques adorn the pages in this
book. In fact, the future would certainly seem to
lie in these other methods, such as wallpaper
stereograms, stereo naturalism, and the many
types of stereo pairs. Other techniques are con-
stantly being developed and refined, largely due
to the flexibility of the computer.

Wallpaper stereograms are based on repeating but offset patterns, which resolve themselves into levels of depth when fused. The earliest examples were described by the English scientist Brewster more than 100 years ago when he noticed that if he stared at wallpaper, any irregularities in the print stood out in depth. Today, the computer enables creative and deliberate use of this effect. The great advantage of this system is that the images can look attractive and interesting even without having achieved fusion. Stereo naturalism involves manipulating a scene, typically a natural history landscape or a view of a crowd or an audience. When fused, a 3-D shape, usually quite unexpected, appears from the scene. This is one of my favorite types. Stereo pairs are the traditional method of presenting 3-D images, side by side. Typically, these were created photographically using a two-lens camera, with the image seen by the left lens of the camera positioned on the left side of the viewer.

A new 3-D fraternity and rebirth/resurgence

is not only assured but is already happening.

In this book, a new generation of stereo pairs is presented, using ever-developing computer technology. "In-com-

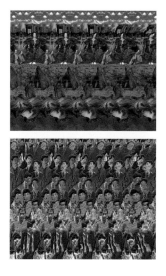

puter" stereo pairs allow virtual-reality situations to be designed on the computer. These "virtual-image" stereograms offer endless opportunities for the computer artists, as initially devised by Snelson, whose works are presented in "The Art of the Stereo Pair" in this book. A derivation of computer creation is computer manipulation, of which the "Stereo Art Gallery" offers a fascinating sampling of classical paintings transformed into depth by the computer artist.

I would not be so bold as to predict where this phenomenon will lead. However, its popularity may redirect the future application of stereoscopic perception. Firstly, publications such as this have enabled huge numbers of people to become aware of the magical ability of 3-D imaging. Secondly, the fact that so many people have learned to fuse stereo pairs will surely lead to a resurgence of the production of 3-D images and imaging techniques for use in science and leisure. In other words, a new 3-D fraternity and rebirth/resurgence is not only assured but is already happening. Computer programs, including those in the public domain, are available, and animated random-dot stereograms have already been created and sold in video format. It is a most exciting time for all those who enjoy viewing or creating stereograms.

Each "stereogram" presented in this book contains a three-dimensional image that can be seen with the naked eye. This unaided stereovision is accomplished through one of two techniques: parallel or cross-eyed.

The Parallel Technique *(Figure 1)*
This technique involves making the lines of sight of the left and right eyes nearly parallel, as if looking at something far away.

The Cross-Eyed Technique *(Figure 2)*
This technique involves crossing one's eyes, so that the lines of sight of the left and right eyes intersect.

The Parallel Technique:
Approach A *(Figure 3)*
Focus on an object in the distance. Maintaining that focal point, insert the book between your eyes and a distant object. The image in the book will be blurry, but that's all right. Try to stare blankly, without actually "looking" at anything. Move the book *slowly* forward and backward. When you reach the right spot, your eyes will focus on their own and the image will come into view.

The Parallel Technique:
Approach B *(Figure 4)*
As in Approach A, start by focusing on a distant object. Without losing that focal point, hold the book flat up against your face. Don't try to bring the blurred image into focus. Move the book *slowly* away from your face. The three-dimensional image will come into focus automatically.

Approach to the
Cross-Eyed Technique *(Figure 5)*
Hold up your finger or a similar object such as a pen between your eyes and the book. Look at the tip of the object. Gradually adjust the distance. When the correct position is reached, the image should come into view.

How to "See" a
Stereo-Pair Photograph *(Figure 6)*
Look at the two dots above the images until they become three. At this point, the center image should look three-dimensional. Some people find it easier to locate a focal point inside the photograph rather than using the dots. With this approach, the sensation is less one of seeing three images than of the two images melding together into a single image.

Each work is marked with a symbol indicating which method, parallel or cross-eyed, you should use to view that work. You can view a work with both symbols either way, but the image will appear differently depending on the method you use, so be sure to try both.

Most of the works in this book have two black dots above them for you to use as a guide. You should see four dots when you first begin to view. When these four dots become three, the three-dimensional image will be visible. Use the dots to find the correct position. Once you have locked on your focal point, shift your consciousness from the dots to the image.

If you still have trouble seeing the three-dimensional images, see pages 90-94 of Cadence Books' *Stereogram* for more detailed instructions.

How to "See" a Stereogram

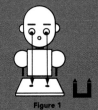
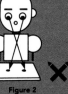

Figure 1 Figure 2

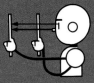

Figure 3

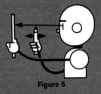

Figure 4

Figure 5

Figure 6

SUPER STEREOGRAM

3D 3D

Countless 3-D artists, driven by the pursuit of beauty and technical innovation, have contributed to the development of the stereogram, and continue to do so every day. The artists presented on the following pages represent not just the state of the art, but its future as well.

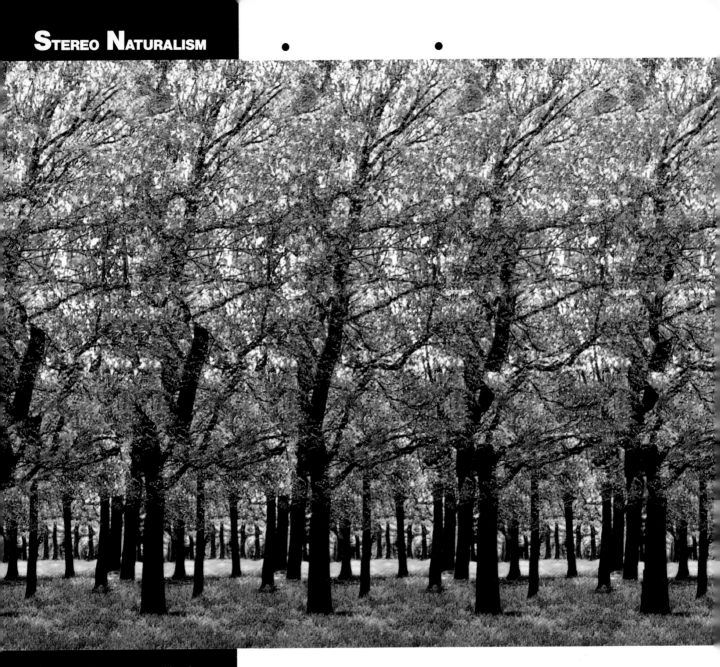

The tranquil state required by the
parallel-viewing technique may be
particularly well-suited to the mind
of the naturalist.

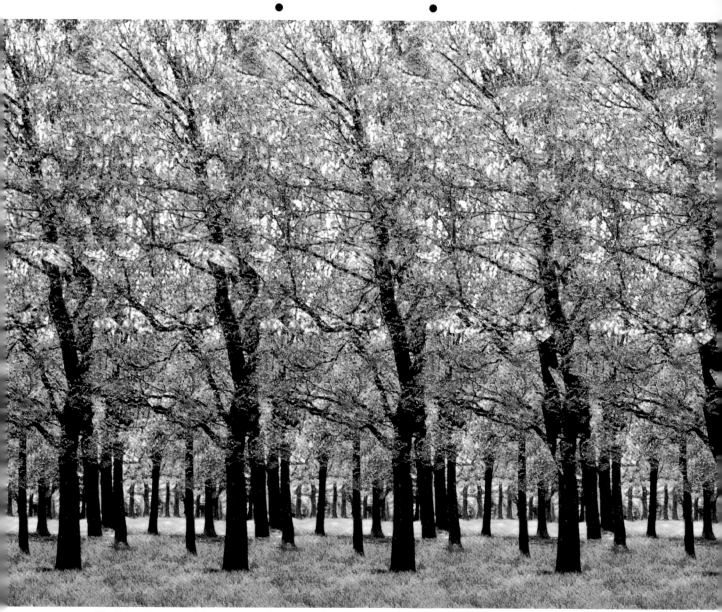

The Forest Comes to Life
Hiroshi Kunoh

*Who is to say that only birds
could come flying out from this
stand of trees?*

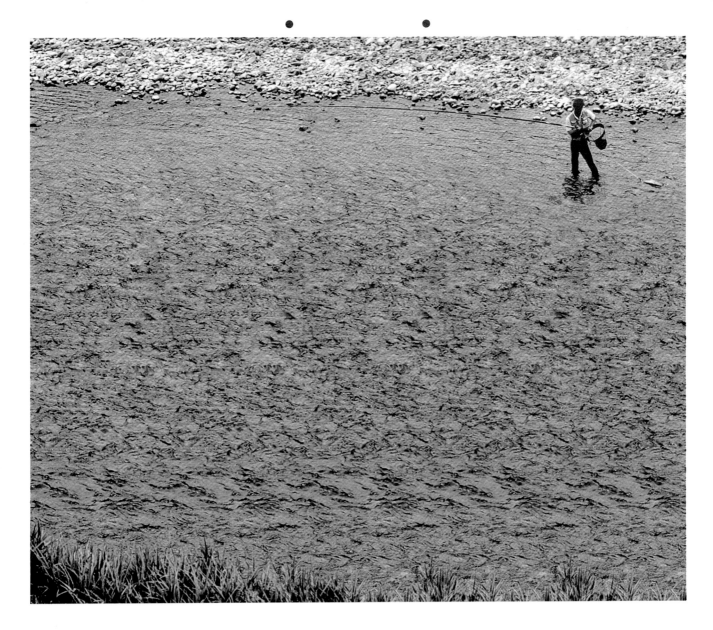

In the Wrong Body of Water
Hiroshi Kunoh

In this elegantly simple nature photograph, you'll see something…well, unnatural.

The Trees Have Eyes
Hiroshi Kunoh

An ordinary wall of foliage proves to be a hidden portal to a watery netherworld.

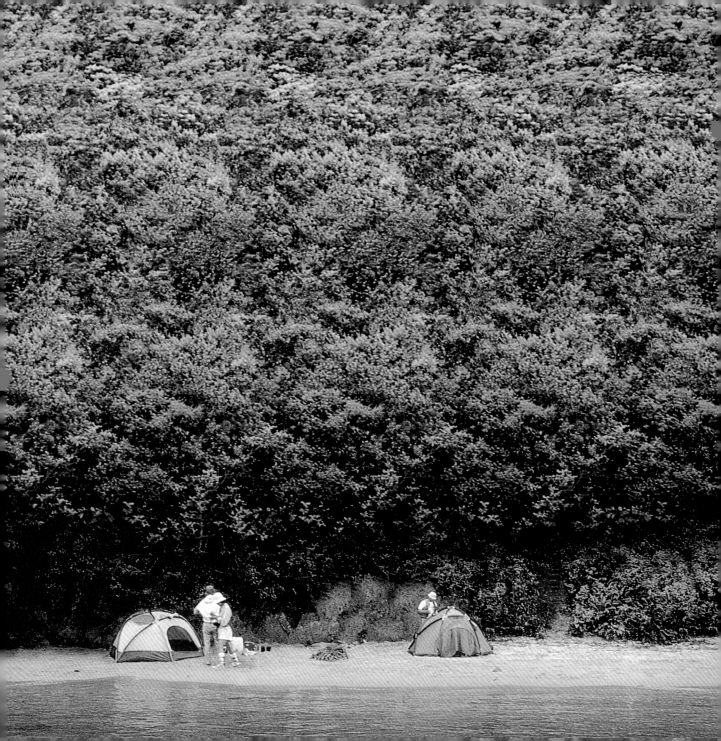

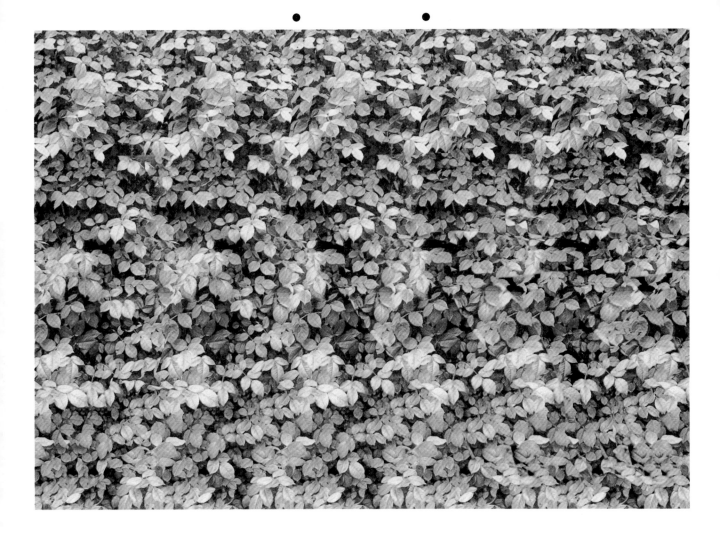

Aquarium in a Forest
Hiroshi Kunoh

A door to the underwater world may be opened at a certain moment in your daily life.

It May Look Quiet, But...
Hiroshi Kunoh

Find something not only in the trees, but in the beach, as well.

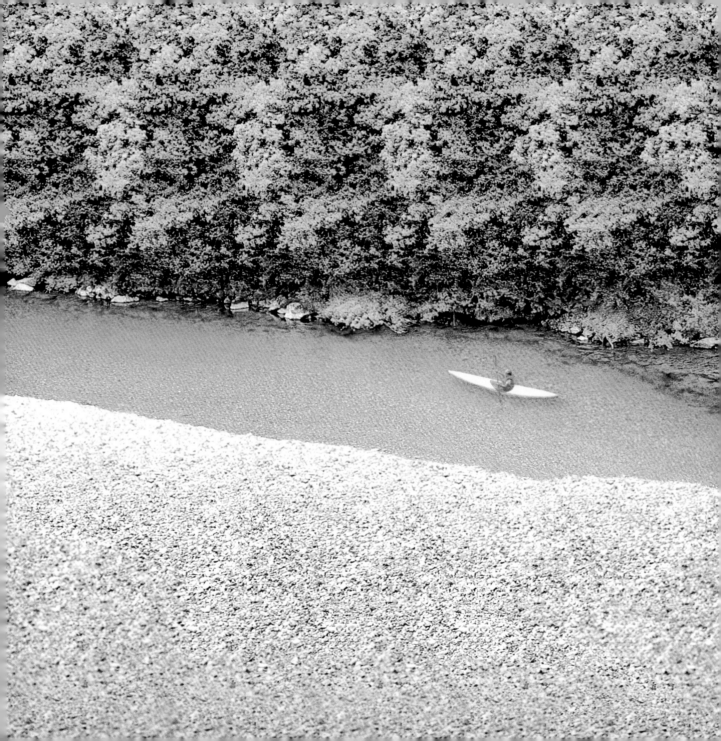

Hunter
Hiroshi Kunoh
The small predator in the leaves seems much larger when it brandishes its weapons.

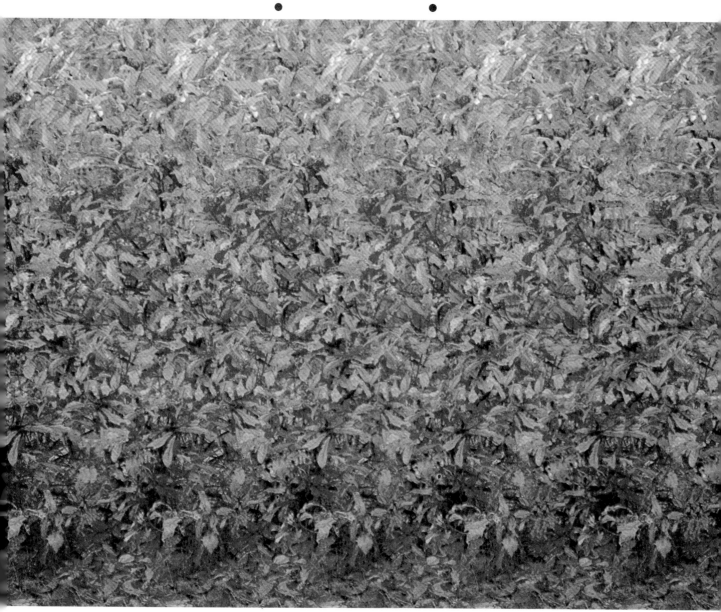

Here They Are!
Hiroshi Kunoh

Some of nature's bounty can be difficult to find, but it's worth the effort.

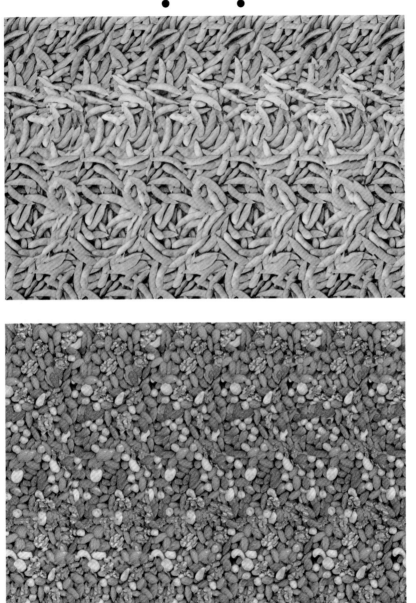

**The Japanese
Love Green Soybeans
with Their
Tyrannosaurus Nuts**
Hiroshi Kunoh

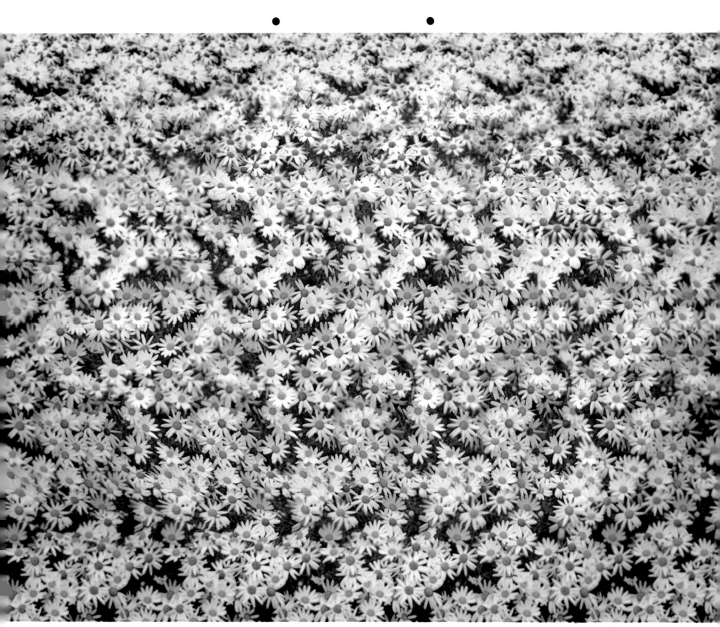

Tea Time
Hiroshi Kunoh
Such a breathtaking sense of depth could only come from a perfectionist such as Kunoh.

STEREO
ART
GALLERY

The work of art brought back to life in 3-D represents a collaboration of tradition and technology. Almost as if the spirits of the great artists have traveled from the past to come reside inside our computers....

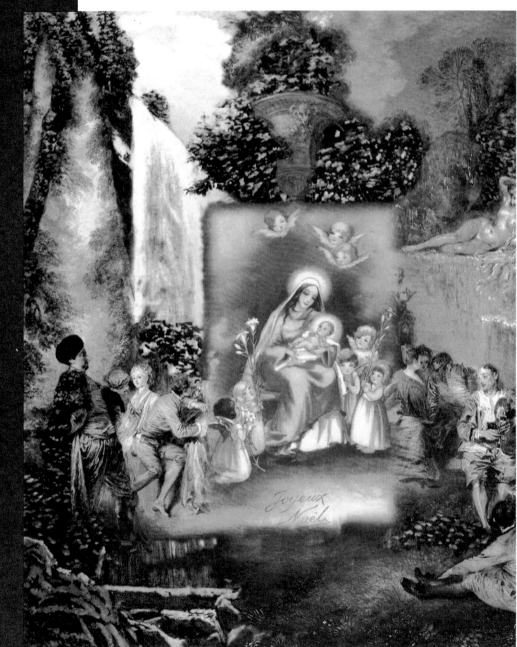

**God—Eternal Love,
Man—Eternal Life**
Tadanori Yokoo/
Makoto Sugiyama
*Yokoo created the collage,
Sugiyama transformed it into
a stereogram using
HyperPaint (Shima Precision
Instruments).*

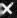

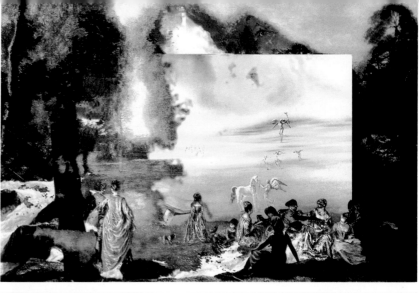

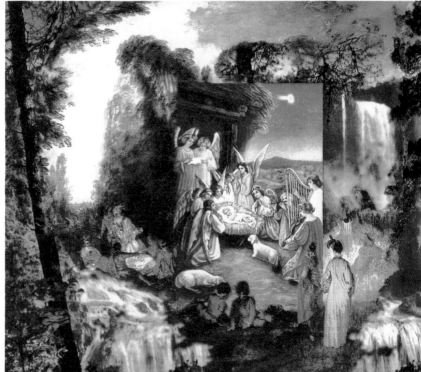

Gentleness
Tadanori Yokoo/Makoto Sugiyama
Although Salvador Dali and others have experimented with hand-made three-dimensional painting, these works represent the dawn of an era of computer-assisted three-dimensional painting.

Art
Tadanori Yokoo/Makoto Sugiyama
These three works by Yokoo are computer-modified versions of two-dimensional works that originally appeared in Love of the Angels: Tadanori Yokoo and Juan Nakamori *(published by Kodansha Comics).*

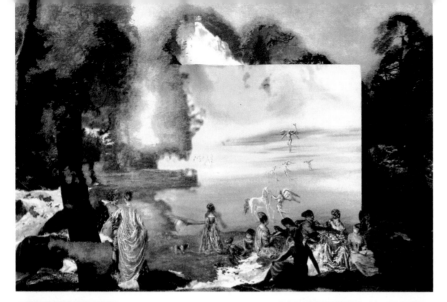

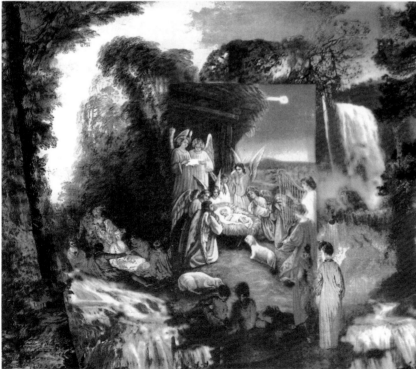

Most of my works are aimed at expressing something four-dimensional, rather than three-dimensional. That is, a variety of time-spaces flow into another time-space. There are waterfalls and people and caves…. Objects from different dimensions coexist.

Stereo photography has existed for a long time, but computer-assisted stereo painting is an experiment that is just beginning. I think making my paintings three-dimensional has heightened their sense of four-dimensionality.

The thing that's interesting about making a picture three-dimensional is that it creates the sensation of a space very different from the real space of which we are normally conscious.

Another aspect that interests me is the sense of transparency in a stereoscopically viewed space. When the proper focal point locks in, something like a glass space appears. I can't help feeling that this sense of transparency originates in the structure of the human eye.

Tadanori Yokoo

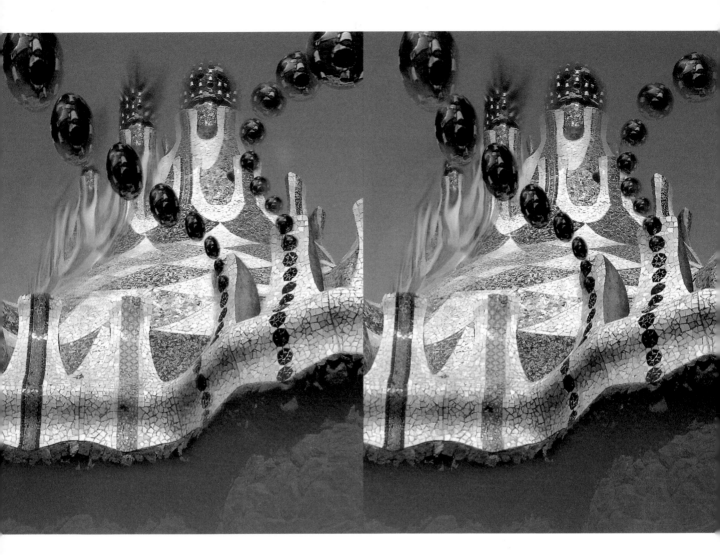

Parque Güell
Gaudi/Makoto Sugiyama
An illusion caused by the midday sun in Barcelona. A single photograph taken at Güell Park was modified using HyperPaint to create this image.

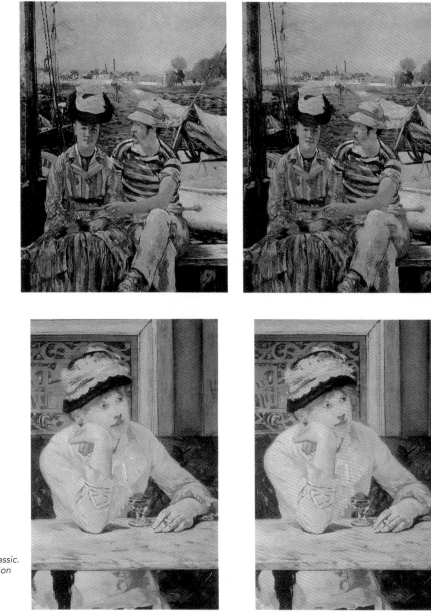

Argenteuil
Manet/Makoto Sugiyama

Another HyperPaint-enhanced classic. You might say this is a collaboration that transcends time and space.

La Prune
Manet/Makoto Sugiyama

Manet's drunken woman, similarly retouched. Take special note of the hand-rolled cigarette.

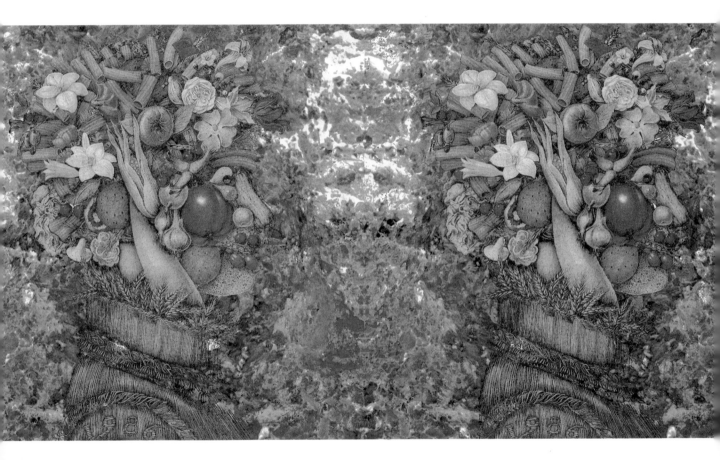

Arcimboldi
Arcimboldi/Makoto Sugiyama
If only Arcimboldi, the great 16th-century Mannerist painter, had had a computer to work with....

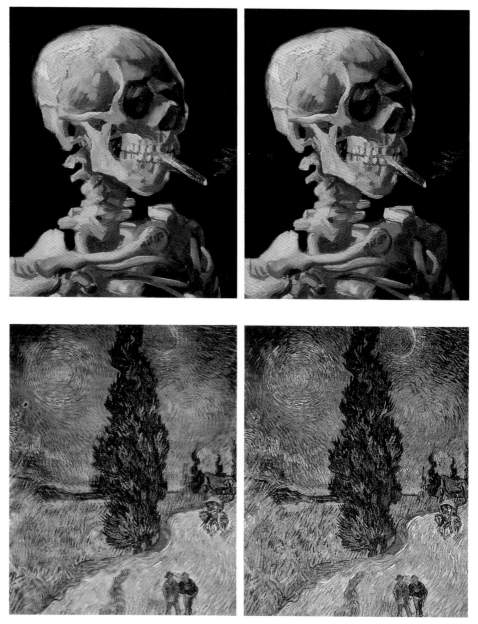

Skull
Van Gogh/Makoto Sugiyama

Van Gogh's unique "Skull with Cigarette," from his Antwerp period.

Cypress and Starry Road
Van Gogh/Makoto Sugiyama

Another experiment with Van Gogh. The "openwork" effect creates the sensation of heated air shimmering.

"FOUND" STEREOGRAMS

Some unintended stereograms. Maybe keeping an eye open for the stereograms all around us is the quickest shortcut to becoming a stereogram expert.

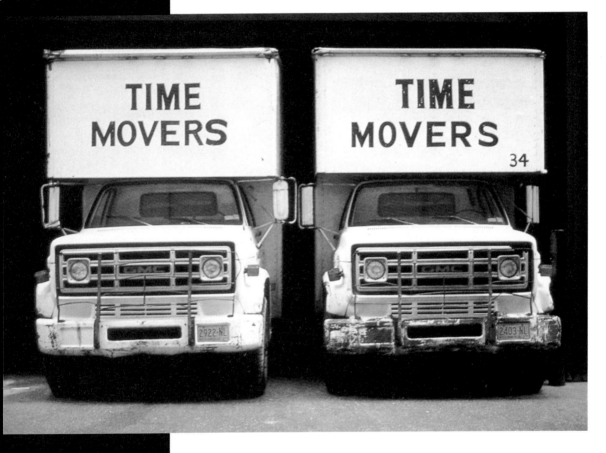

Time Movers
Discovered by Chieko Yamamoto

The trucks in this Dutch postcard form an unplanned stereo pair. The lettering is particularly intriguing. © Henry Cannon, 1979/New York

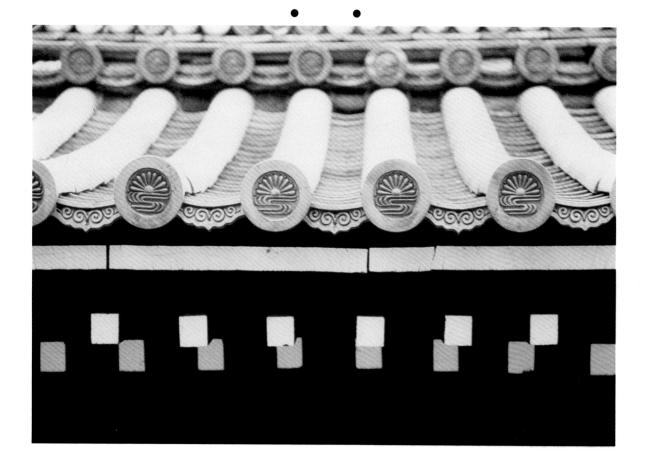

Japanese Roof Tiles
Discovered by Hiromichi Kakuyama
at a photo agency. © Orion Press

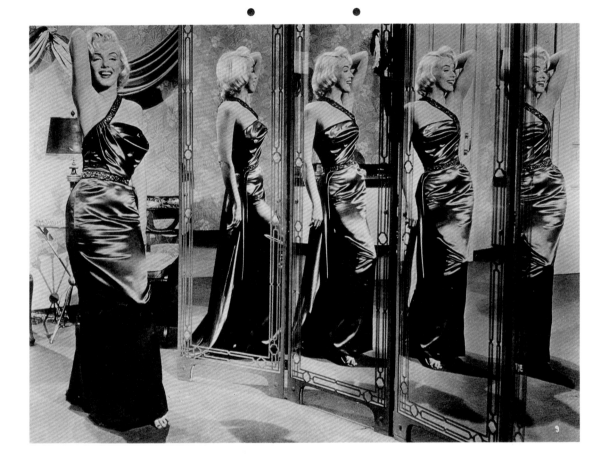

Monroe Wall
Discovered by the Editorial Staff

By a strange trick of fate, this still from How to Marry a Millionaire *works as a wallpaper stereogram of Marilyn Monroe.*

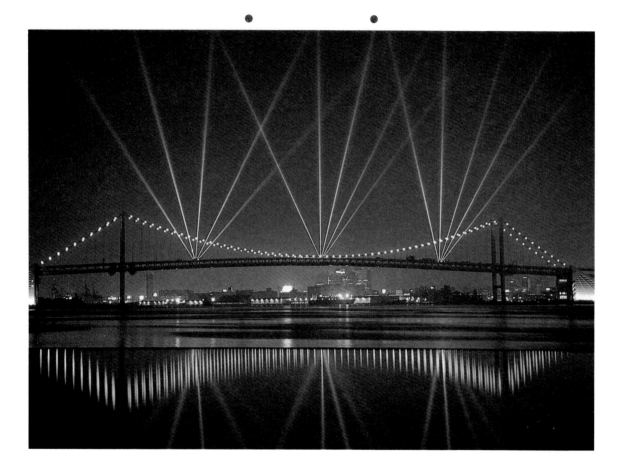

Rainbow Bridge
Discovered by the Editorial Staff

This was taken by photographer Keisuke Kumagiri when the bridge was lit up on June 9, 1993 to commemorate a historical event.

HYPER COLOR FIELDS

The color field stereogram continues to evolve at breakneck speeds in its details and complexity.

Tao
Shiro Nakayama

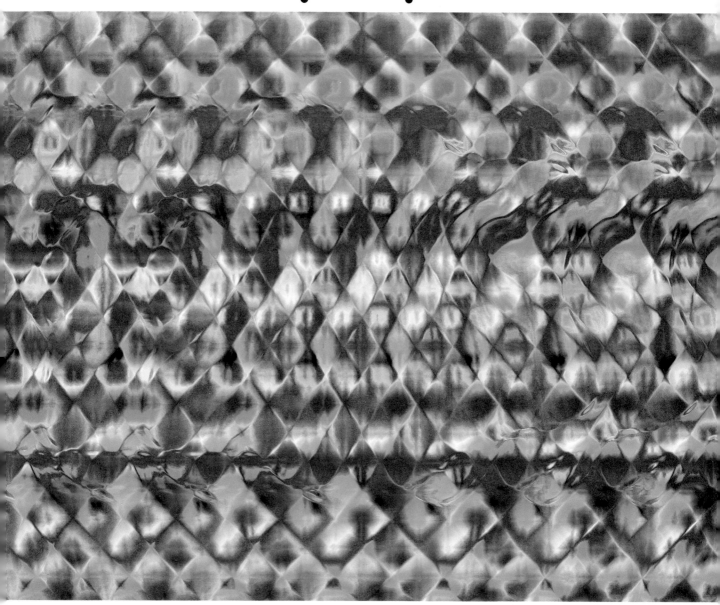

Comfit
Shiro Nakayama

In both this and the preceding stereogram, Nakayama is striving for a sense of transparency.

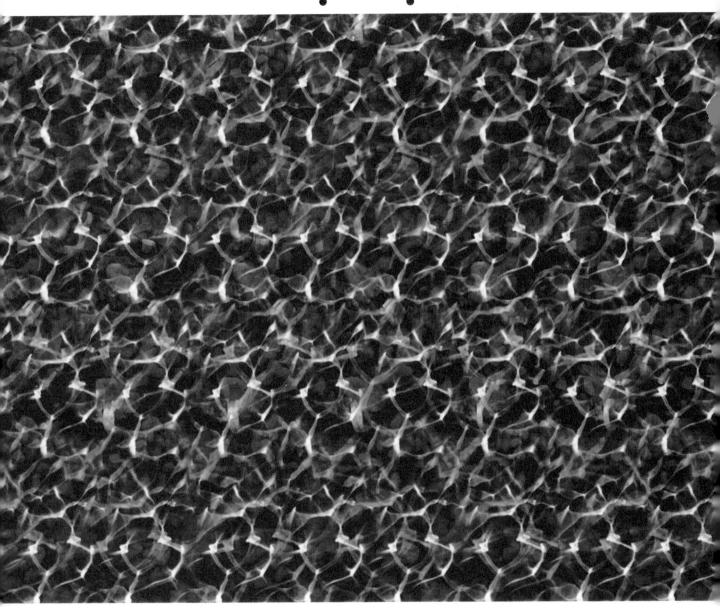

Nessie
Shiro Nakayama
Behind concentric circular waves, you'll see Nessie swimming by like a ghost.

Net-work
Shiro Nakayama
Nakayama is well-known for smoothly curving surfaces, but here he manages to express empty space as well.

Beetle
Izuru Fujita
The classic Volkswagen parked on an incline. Examine carefully and you'll see such details as the side mirror.

Lily
Izuru Fujita

A single lily composed of some 45,000 polygons. Note that the stem grows right out of the "ground."

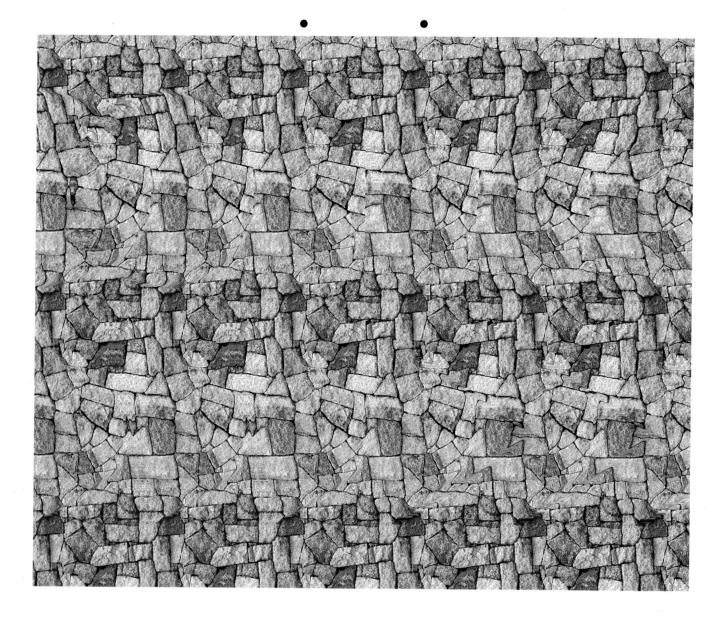

Ishigaki (Stone Wall)
Jun Oi
Oi's meticulously crafted photo-field stereogram seems to pay homage to the painstakingly wrought wall.

Suimen (Water Surface)
Jun Oi

*Out from the dazzling sparkle come
swimming two streamlined fish.*

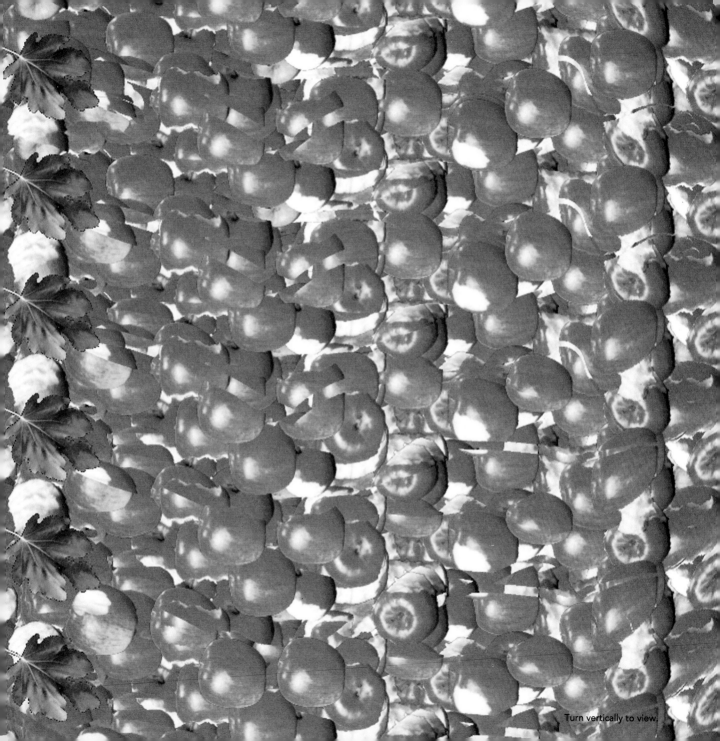

Turn vertically to view.

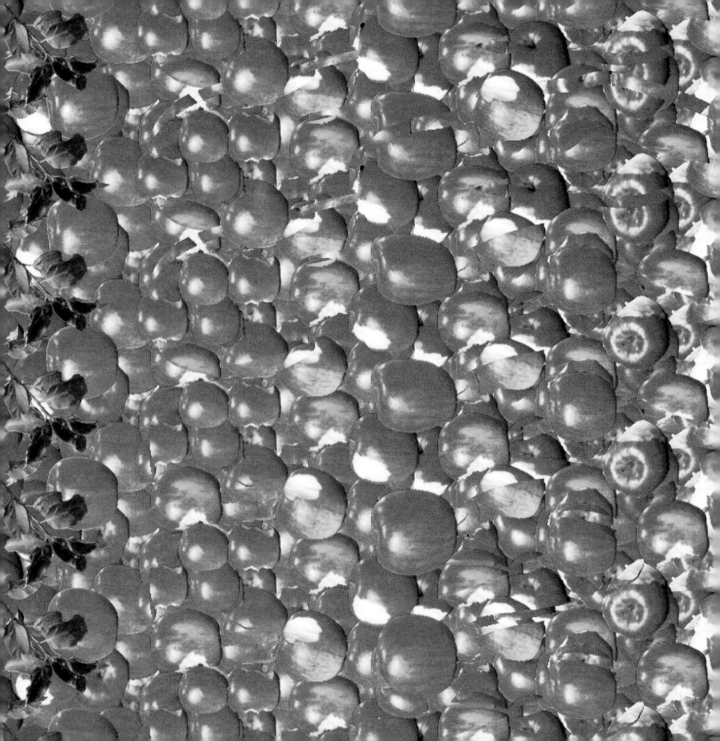

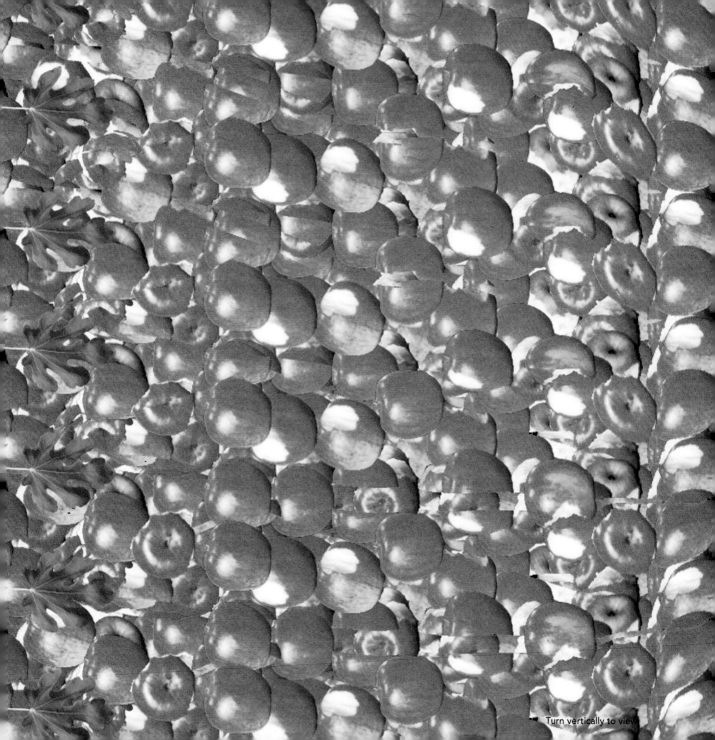

Turn vertically to view

Adam & Eve (pages 42 to 45)
Eiji Takaoki

The fig leaves overlap with the progenitors of humankind in, well, just the right spot. (Turn vertically to view.)

Acala, the God of Fire
Eiji Takaoki

Acala, the form assumed by Mahavairocanasatathagata Buddha to overcome worldly desires.

THE ART OF THE STEREO PAIR

The stereo pair, with its century-long history, is being reborn as a medium of the future.

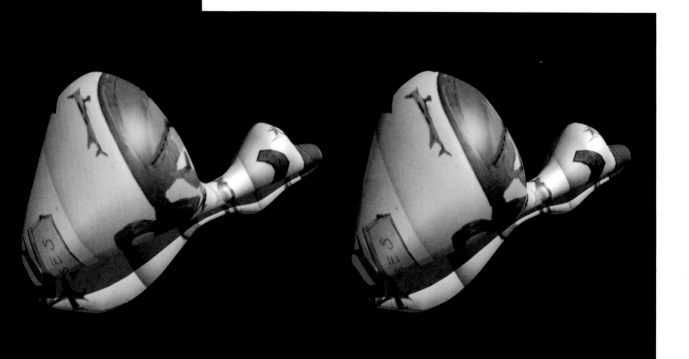

Electronic Collaboration
Katsuhiko Hibino and
Propeller Artworks
A stereo pair made from the first electronic design work by Hibino, a renowned modern artist.

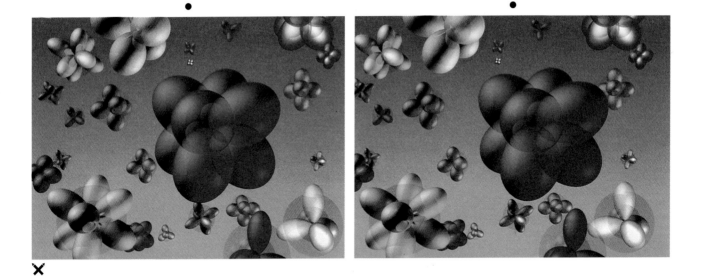

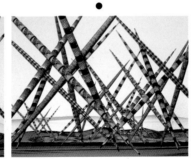

Schrödinger Balloons
Kenneth Snelson

Polescape
Kenneth Snelson

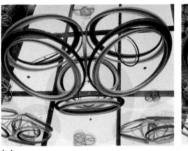

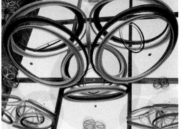

Invasion
Kenneth Snelson

Leonardo's Discovery
Kenneth Snelson

Leucippus Landscape
Kenneth Snelson

Forest Devils' Moon Night
Kenneth Snelson

*This highly acclaimed modern art
sculptor is also a great modern
stereo-pair artist working to bring
the long tradition of the stereo
pair into the future.*

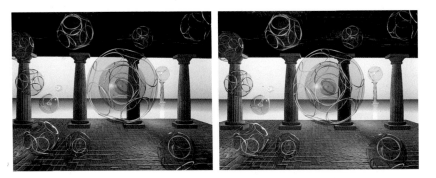

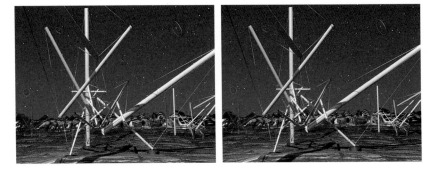

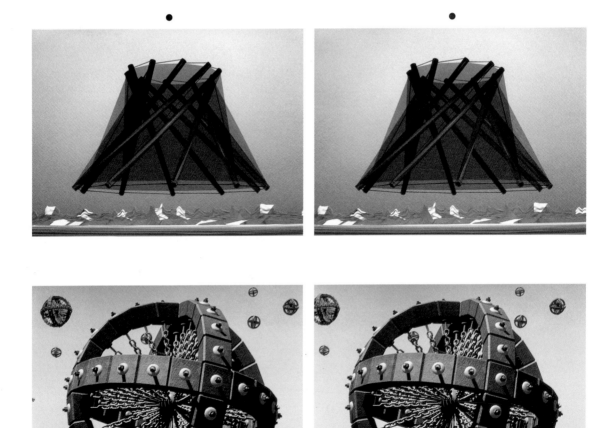

Shroud Drift
Kenneth Snelson

Chain Bridge Bodies
Kenneth Snelson

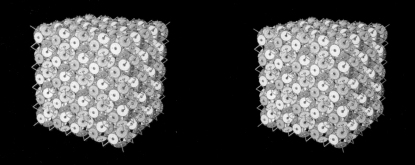

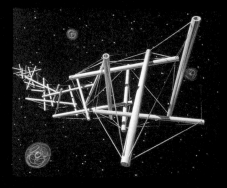
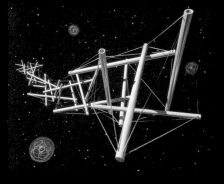

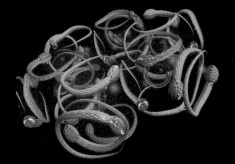
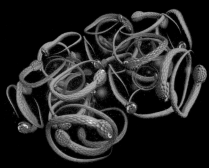

**Cube of
Gear Chain Magnets**
Kenneth Snelson

Landing
Kenneth Snelson

Kekule's Dream I
Kenneth Snelson

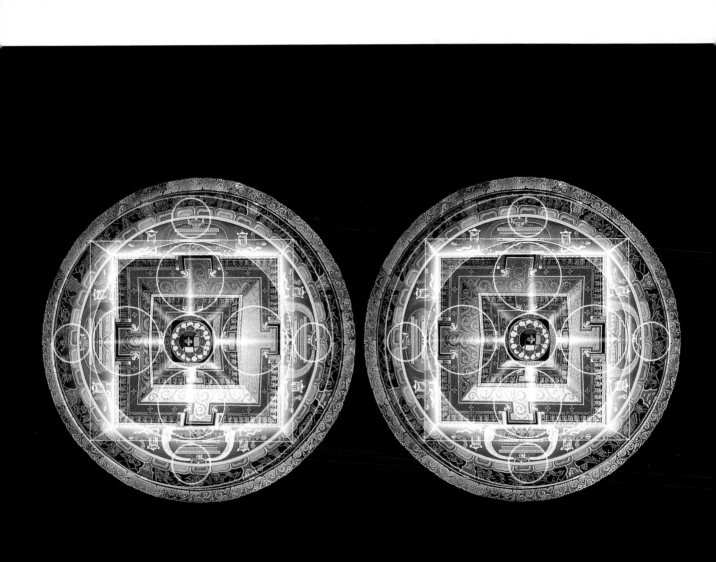

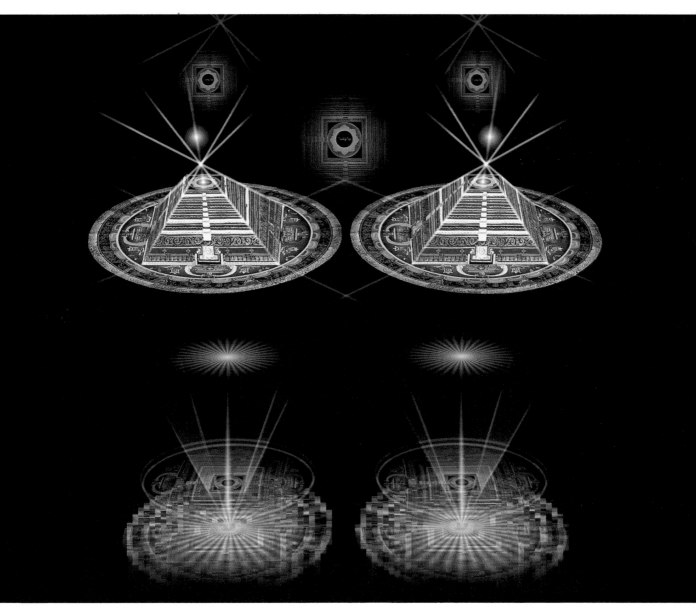

Mandala
Makoto Sugiyama

*Using HyperPaint once again,
Sugiyama offers his interpretation of a
traditional Vajrayāna Buddhist art form.*

Linger on the details of color, shape, expression, and gesture in the animals—ancient, contemporary, and caricatured.

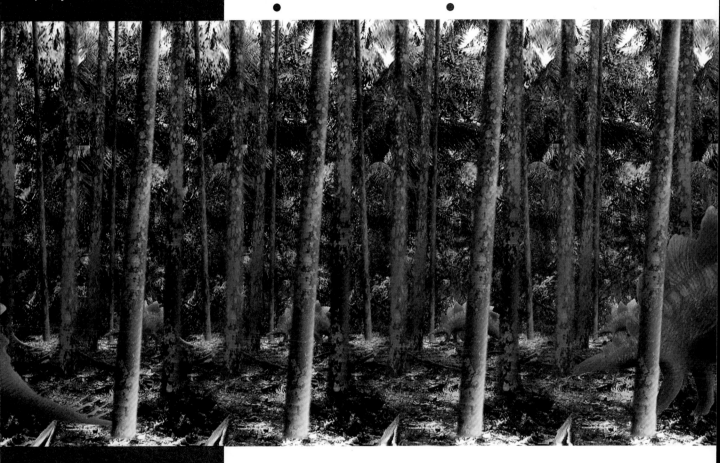

Jungle
Takashi Taniai

A trans-time tourist spots a stegosaurus in the primeval forest.

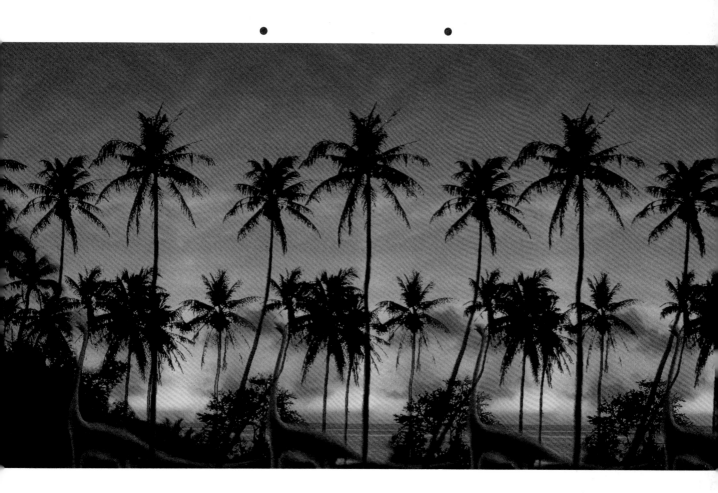

Twilight in Paradise
Takashi Taniai

You may not notice the sauropod until you look at the image stereographically.

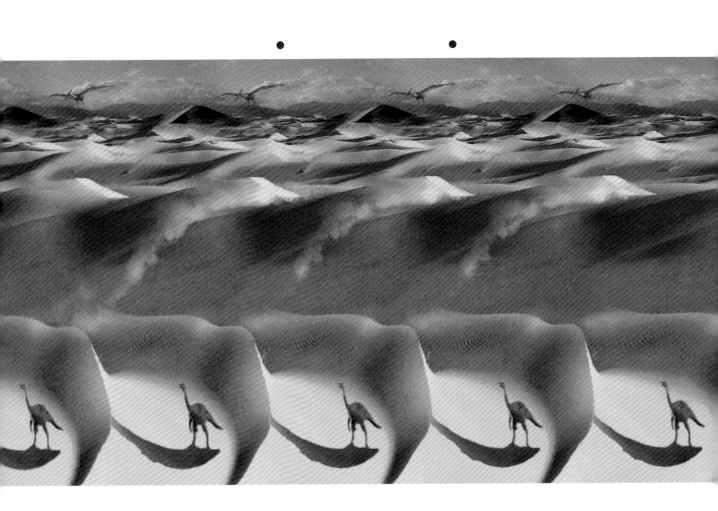

Desert
Takashi Taniai

Beyond the cloud of dust, the desert sprawls. In the distance, the horizon meets the sky.

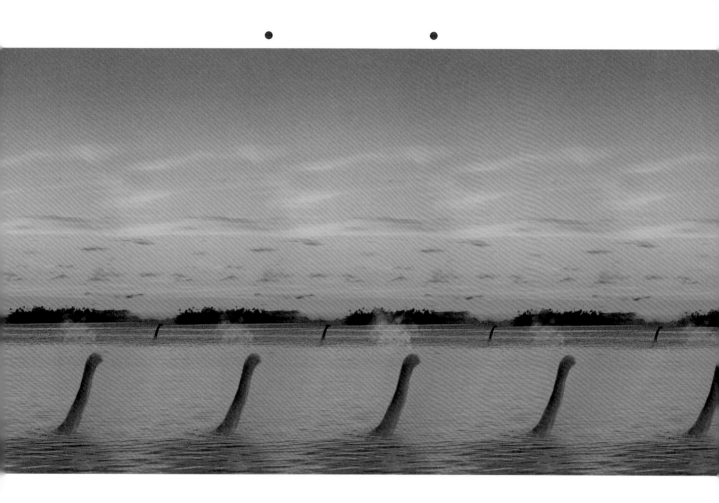

Blue Stillness
Takashi Taniai

You can almost hear the breathing of these leviathans.

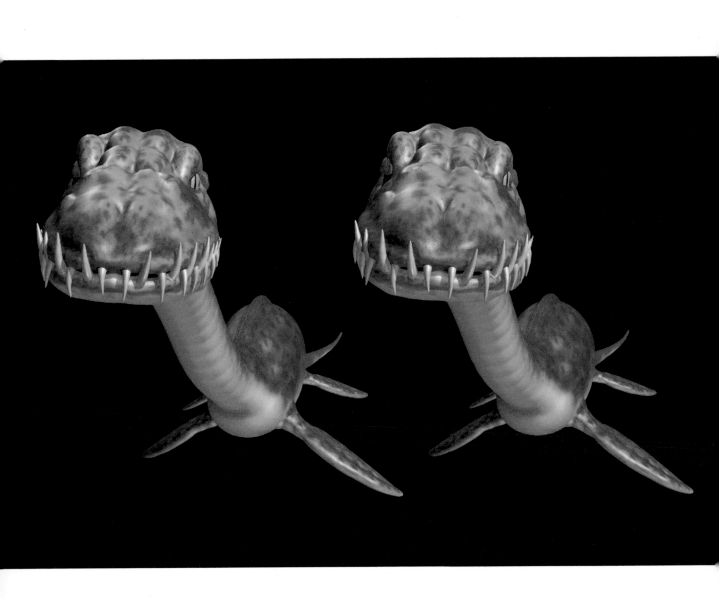

Elasmosaurus
Michiru Minagawa

Elasmosaurus was a plesiosaur (marine reptile), not a dinosaur.

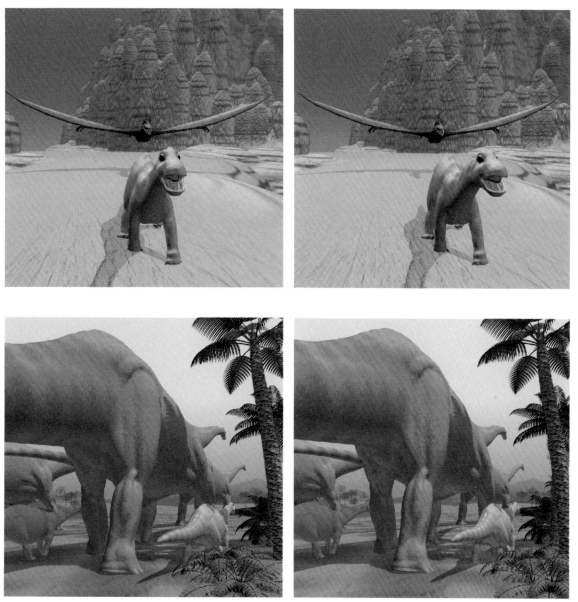

Ripple & Paw
Michiru Minagawa

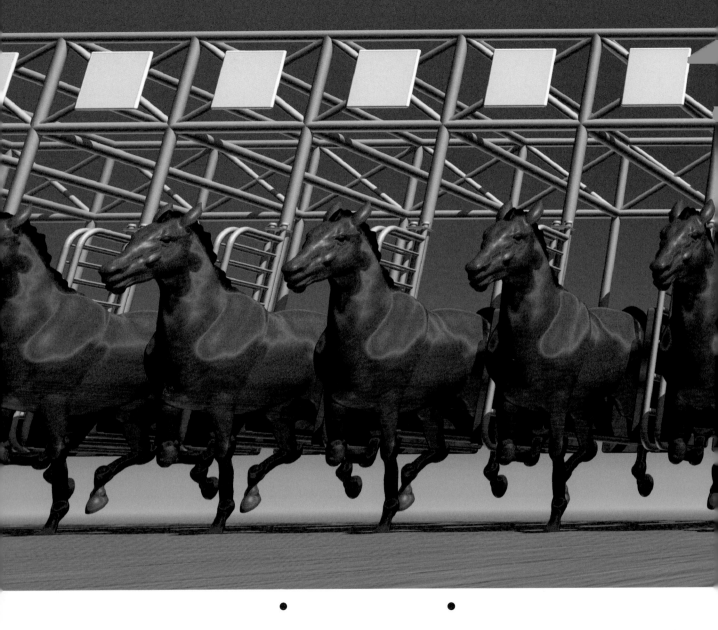

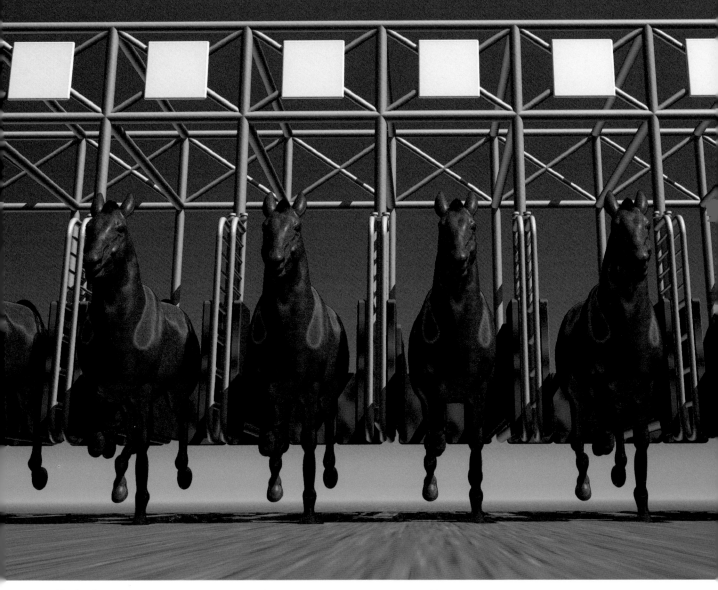

Fanfare!
Tatsuhiko Sugimoto
And they're out of the starting gate! These thoroughbreds are all computer graphics.

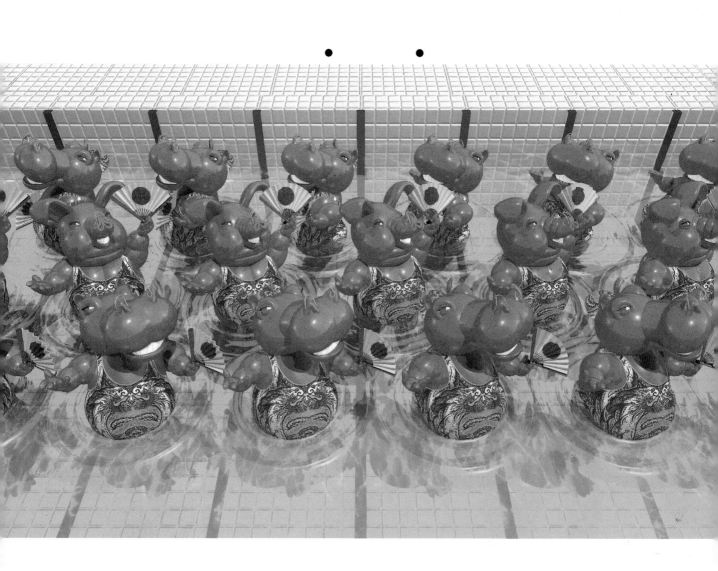

Synchronized Swimming
Kan Dava

The transparency of the water and the brilliantly rendered textures create a vivid sense of "realness."

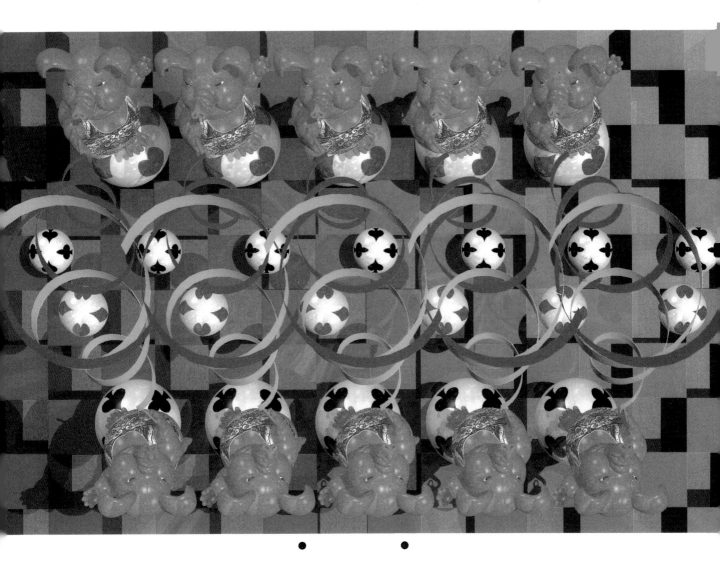

Rhythmic Gymnastics
Kan Dava
A porcine parade of pink performers.

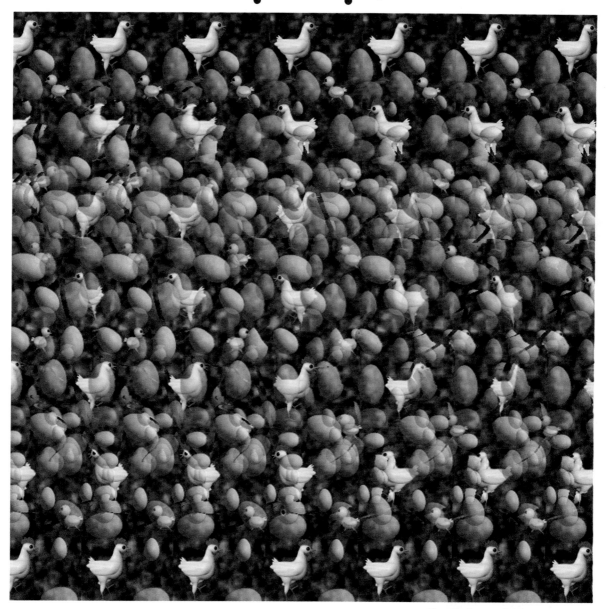

The Chicken and the Egg
Michiru Minagawa
Perhaps this troubling question boils down to the difference between a cross-eyed and a parallel view.

STEREO COMICS

Comic heroes brought back to
life in vivid 3-D. The spirit
of the stereogram is
indisputably the spirit
of playfulness.

Accident
Hisashi Eguchi
*This drawing by a popular Japanese
comic artist was transformed into a
stereogram using Adobe Photoshop™.*

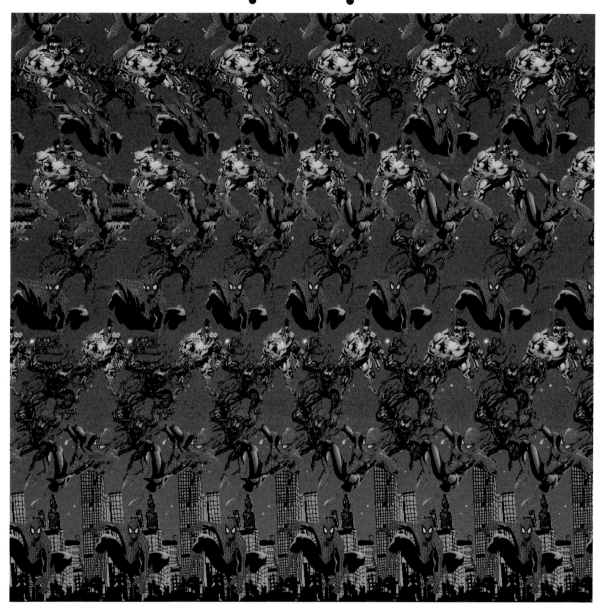

Spider-Man
HAL

This American comic hero comes to life.
Spider-Man™ © Marvel Entertainment
Group Inc., 1994. All rights reserved.

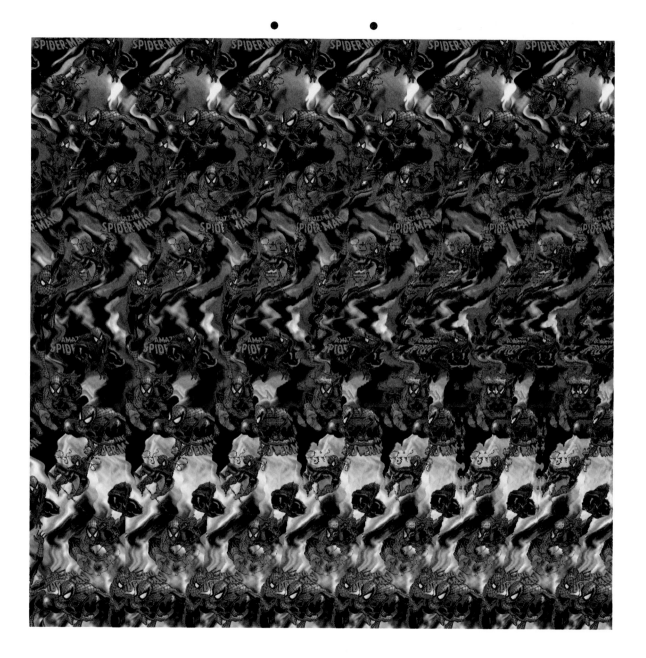

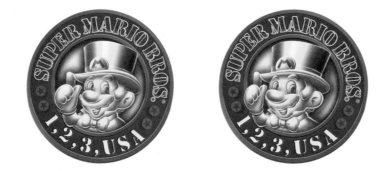

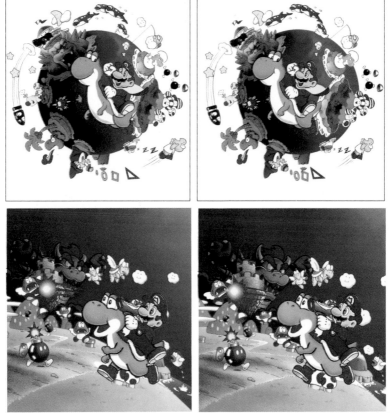

Super Mario World
Makoto Sugiyama

The Japanese-born international hero, now transformed into a stereo pair. © Nintendo

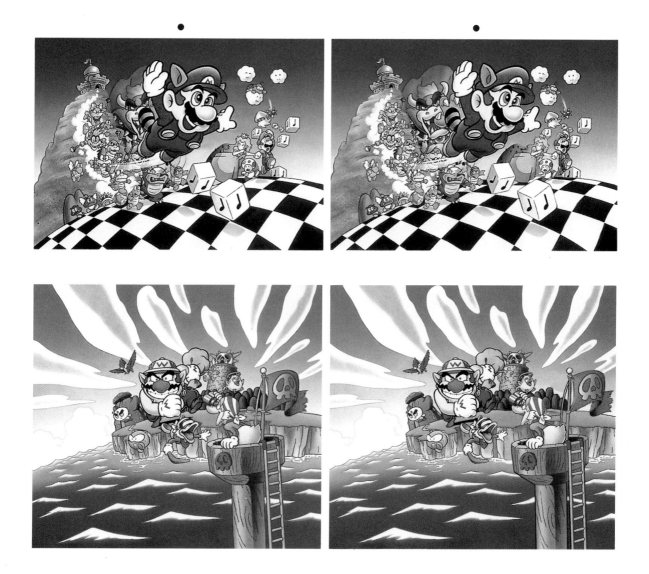

Super Mario World
Yoshitaka Kokubun
© *Nintendo*

STEREO FANTASIA

The mother of all dreams and fantasies is the very brain—your brain—that extracts the three-dimensional image from the two-dimensional page.

X

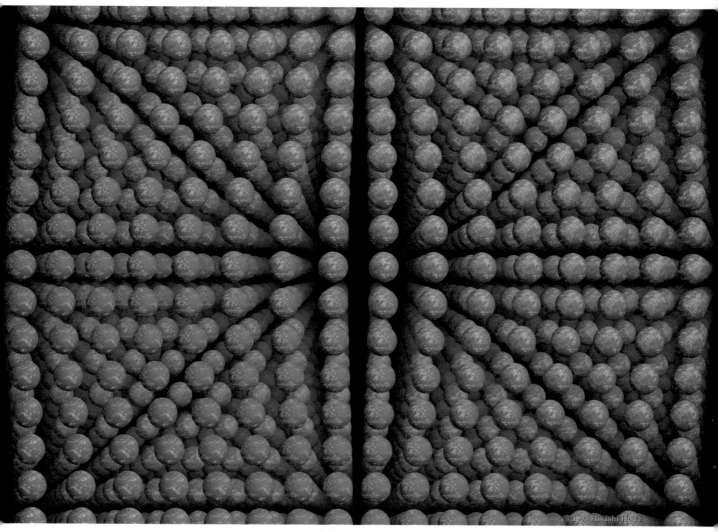

Plateau 8
Hisashi Houda
(Earth by Naoyuki Kato)
The depth and dimension of this stereogram is overwhelming.

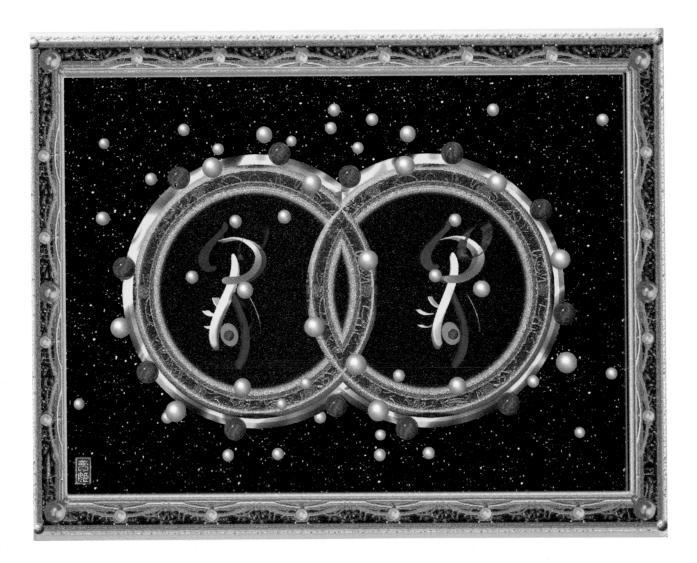

**Wa no Yumeji
(The Circle's Dream World)**
Mayumi Dava
*In the center is a visual play on the
Japanese word for "dream."*

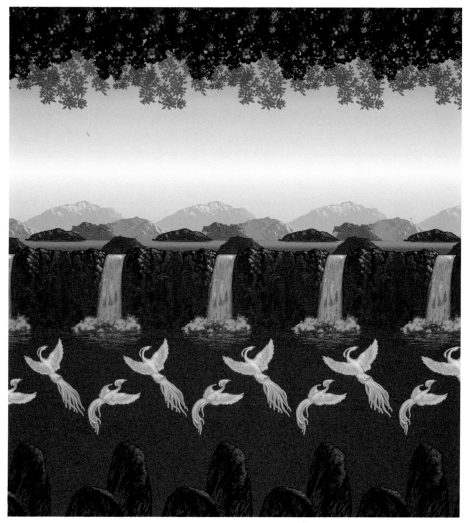

Landscape
Miyuki Kato
*The color and sense of lighting are
inspired by illustrator Maxfield Parrish.*

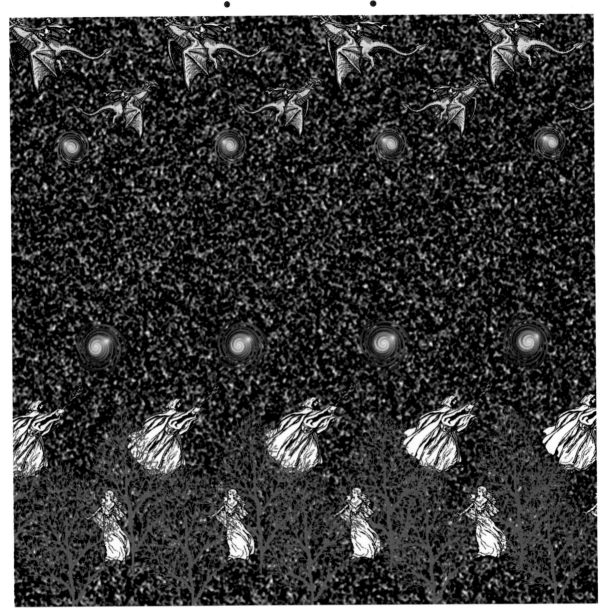

The Castle
Miyuki Kato (with Naoyuki Kato)
*You can see an old castle
in the background.*

Pyramid
Kengo Tsukasaki (with Naoyuki Kato)

The background symbolizes the cosmology of ancient Egypt.

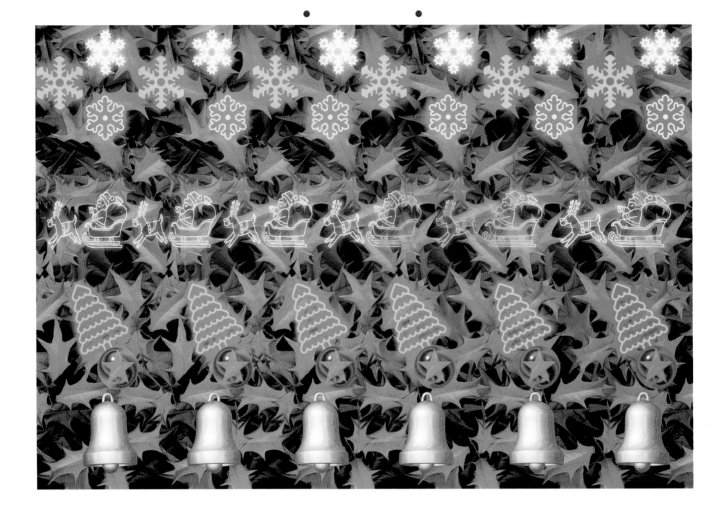

Christmas
Hiroshi Kunoh

*Christmas lights are brighter
this year in 3-D.*

Ghost
Shiro Nakayama

Pumpkin
Shiro Nakayama
*Can you carve a pumpkin
better than this?*

Neo-Mandala
Mayumi Dava
The depth of the many colorful "sprinkle" spheres gives a new dimension to the shape of the mandala.

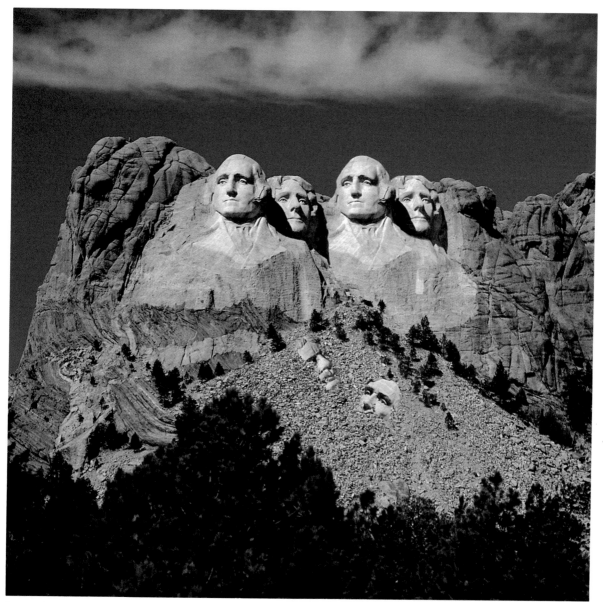

Mt. Rushmore
Masayoshi Obata
*At first glance it looks familiar
enough, but there's something amiss.*
© Orion Press

The two pioneers of stereogram art continue to show their subtle sense of black humor.

45°
DIN

That's Celsius, of course, as the scene would suggest.

Time Trap
DIN

*Japan's past and present
mixed in 3-D.*

No Longer Mr.
DIN

*The eating habits of the
Japanese people are changing.*

Not Really
DIN

Japanese businessmen's dilemma,
according to DIN.

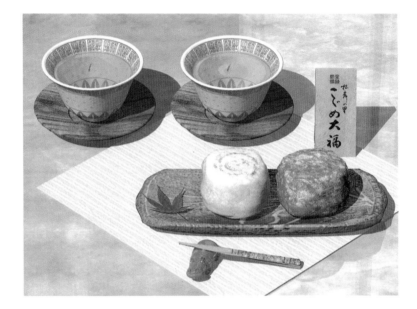

A Cup of Happiness
Kan Dava

*Your eyes are probably tired by now.
We can't resist the Japanese impulse
to offer a cup of tea and a sweet in
thanks for your effort.*

by
Shinsuke Shimojo

Department of Psychology,
University of Tokyo

Photographs by
Joji Sawa

"The random-dot stereogram to me? It's a bit like 'Bolero' to Ravel."

—*Bela Julesz*

Just a few years after the publication of Bela Julesz's The Foundations of Cyclopean Perception *(University of Chicago Press: 1971), I was a lazy student in experimental psychology at the University of Tokyo, with no idea of what to do for my senior thesis. One day Sato, a graduate student who always made me feel as if he were my elder brother, said to me, "Come over, Shimojo. I will show you something exciting."*

I was always bored, and that day was no exception, so I followed him to the dark room not expecting much. He then told me to keep both of my eyes open and to look through an optical apparatus, the name of which I later learned was a "haploscope" (essentially a professional version of a stereoscope).

I still remember vividly what happened to me (or what happened to my eyes, perhaps

I should say) in the following several seconds. "Gosh!" I yelled. I heard Sato giggling behind me. He told me to close and open one of my eyes repeatedly. And needless to say, the square which was floating in front of a textured background appeared and disappeared accordingly. And then he said, "What, Shimojo? You don't know about this at all?" in his typically contemptuous tone. It may sound absurd, but my first perceptual experience was somehow "super real"—even more real than real objects. It looked more than merely three-dimensional to me.

Anyway, this was how I first encountered the random-dot stereogram and thought about its inventor Bela Julesz, my future academic hero. Ever since, my relationship with the random-dot stereogram has continued, sometimes as a research tool, sometimes as teaching material, and sometimes just as a toy to play with.

For us researchers, the random-dot stereogram has become a matter of common sense. But I never imagined that it could become well-known and even fashionable

Interview with Bela Julesz

among ordinary people in the street, until I found it in one of the popular photo magazines, practically a counterpart of People magazine.

Last year, I finally found a chance to interview Professor Julesz at the Laboratory of Vision Research, Rutgers University, where he is the director. The beautiful autumn morning was perfect for one of our purposes, to shoot stereo photos of Julesz.

Shimojo: We can track back in your publication list to an article published in 1960 as the first article that officially described the random-dot stereogram. How did it occur to you at the beginning? Was it a new discovery of visual perception? Or rather, a great invention of a tool for research?

Julesz: I was originally a communication engineer working with radar. Everybody in the field thought it to be common sense that camouflage could be broken in the

stereo photo, and that shapes which could not be visible monocularly could jump out in depth. So when I started reading the psychological literature of stereoscopic depth perception in the late fifties, I was startled to learn that the mainstream psychologists did not think that way. They thought that stereopsis was an enigmatic problem, based on monocular form recognition and shrouded in the mystery of semantics. Now, a computer could do a perfect camouflage. All I demonstrated then was to break it by stereoscopic depth.

Shimojo: So, in what specific sense was it innovative and original?

Julesz: I never considered it to be a great intellectual achievement, despite its many consequences for brain research.

In my case, I should say it was sort of a transformation skill. Transformation from

BELA JULESZ
Born in Hungary in 1928. Julesz was a laboratory technician in Hungary who moved to the United States in 1956 after the Hungary Rising to start work at Bell Institute (now AT&T Institute). In 1960, Julesz developed random-dot stereograms, creating a sensation among perceptual psychologists. Currently director of the Laboratory of Vision Research, Rutgers University.

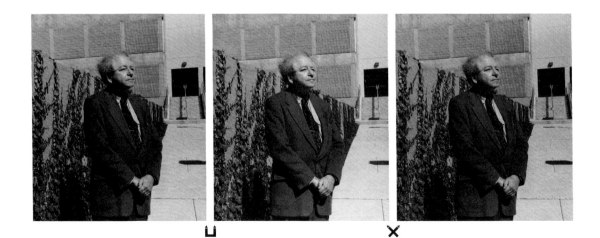

one field to another, from communication engineering to visual perception, in this case. It was rather like a lucky coincidence, or like a clash between two cultures. Since it is an association between two languages, I call it "remote bilingualism," or "scientific conjugacy."

I have brought everybody's knowledge in radar engineering into a different field, perceptual psychology.

This rather modest comment reminded me of what Julesz wrote in a special article to celebrate a quarter-century anniversary of Vision Research, *one of the leading journals in our field (1986, vol. 26, pp. 1601-1612). I would like to cite a brief excerpt here, although I strongly disagree with his first sentence:*

"It should be emphasized that my use of computer-generated random-dot stere- *ograms was only a minor contribution. While computers permit ideal camouflage with absolute stimulus control, there must have been dozens of stereo photographs taken from balloons or airplanes of densely textured scenes that emulated random-dot stereograms quite well. (In an article by Babington-Smith, 1977, one can see the floating ice on the River Rhine in a 1940 British aerial reconnaissance photograph of Cologne taken from two nearby vantage points, and the pieces of ice portray interesting surfaces in depth, particularly in the vicinity of the piers of a bridge, where the ice flow is altered.)" [p. 1602]*

Shimojo: How do you feel about your own contribution of the random-dot stereogram? What were the advantages of the random-dot stereogram at that time, from a scientific viewpoint?

Julesz: As far as I can see, there are three merits in the random-dot stereogram. First, I have brought everybody's knowledge in radar engineering into a different field, perceptual psychology, as I have just mentioned.

Second, I have used a computer, probably for the first time in psychology, to create stimulus figures. As a result, I could completely eliminate monocular depth cues. In fact, there had been several pioneer researchers who tried things such as cut-

The study of early visual processes has been established through my lifetime work as a division of psychology and as a part of hard science.

ting pieces of sandpaper and sticking them on cardboard with a disparity, just to obtain the same binocular depth effects. However, they could not completely eliminate cues including monocularly visible contours. It was fortunate in a way, although it may sound ironic, that I had to escape from Hungary because of the Hungarian Revolution in 1956 and ended up with a job at the Bell Telephone Laboratory. So, in addition to gaining freedom, I got access to the first digital com-

puters because it was impossible to find a computer in Hungary at that time.

Third and finally, the study of early visual processes (early neurophysiological processes of visual perception) has been established through my lifetime work as a division of psychology and as a part of hard science.

Shimojo: Gathering from the first point that you've just made, you had regarded stereoscopic vision not as a mechanism of depth perception, but rather of camouflage breaking. Is that right?

Julesz: Indeed. Consider the freeze response in various insects, for instance. And remember that the mammalian species which were our ancestors were probably all predators. It seems reasonable then to assume that they had acquired stereopsis as such a complicated camouflage-breaking apparatus. In this regard, motion perception is somewhat similar to stereopsis. This was exactly my motivation to develop the random-dot cinematogram, side by side with the random-

dot stereogram between 1959 and '60. In the random-dot cinematogram, a shape could be perceived only by the motion of the dots.

Shimojo: And yet ever since, you have mostly concentrated on the random-dot stereogram, not the cinematogram. What is the reason for this?

Julesz: The cinematogram was not easy to actually demonstrate with the technology level at that time. Even when I wrote an article, I could demonstrate the stereograms on pages, but I could not demonstrate the motion-defined effects. It would be extremely boring just to describe a novel visual effect only by statistical figures, wouldn't it? I used to carry around a Polaroid screen for a demonstration whenever I gave a talk.

Shimojo: You realized very well the importance of demonstration in science.

Julesz: Some people take science too seriously. For one thing, science should be fun. I have never regretted my choice at

that time because there have been so many researchers of a younger generation who have since said things to me such as, "I decided to choose psychobiology as my field, owing to you!" I still consider this to be the highest honor in my life.

Shimojo: Ah, I am one of those, as you may know.

I was so moved at this point that I couldn't refrain from asking a very personal question. And he remembered. Back in 1977, I was still a graduate student struggling for my first publication. Even though I was a nobody in the field, I had suddenly decided that I should send my manuscript to the professor because my work was on plasticity of stereopsis, and the random-dot stereogram was a critical part of its methodology. I don't really remember, but at the time my English must have been at the level of just barely making sense.

Instead of throwing my paper into the trash box, he read it and gave me a great many suggestions and encouragements. The paper was eventually published in a

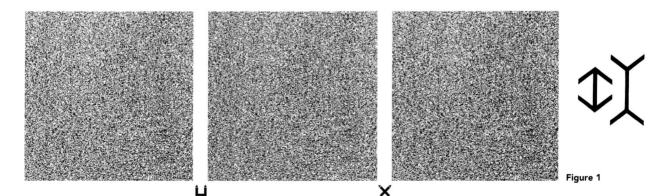

Figure 1

respectable journal, owing to his recommendation, and this determined my fate as a researcher in visual science. I mention this not for my own vanity, but rather because I have heard very similar stories about Julesz from several other top-class researchers in my generation.

Shimojo: By the way, I have heard from some senior researchers that at the beginning, the random-dot stereogram had not been accepted in the field at all.

Julesz: Well, that was the thing. I first presented my work on the random-dot stereogram in 1960 at the meeting of the Optical Society of America. A famous professor, who was actually the chairman of the meeting and the authority of stereopsis, turned it down as some side effect of the experimental equipment and rejected my article for publication in the journal. He even quoted Helmholtz, trying to prove that he was right, and it was not a very accurate quotation. Believe it or not, even six years later, he was still claiming in an article that the effect was an artifact by monocularly visible cues.

Shimojo: From today's viewpoint, it is rather hard to believe that he did not believe it. The fact was that the depth and the shape were binocularly perceived. It may be one of those cases where experts have a hard time in abandoning mainstream notions, even when facing plain evidence against. But at any rate, what happened then?

Julesz: I was very disappointed, as you can imagine. I stayed in the lab, not attending conferences or anything in the following several years. But the general director of the Bell Laboratory at that time, Dr. Pierce, strongly backed me up, so I kept working and publishing the article in *Bell System Technical Journal*. Eventually, people recognized the real value of my finding. So when I finally attended a conference after a little while, I was surrounded and applauded by people. They said, "Oh, this is *the* Julesz!"

In retrospect, however, I think the scientific controversy between the stereopsis authority and myself may have drawn people's attention to my findings sooner than

Figure 2
Shinsuke Shimojo interviewing Bela Julesz.

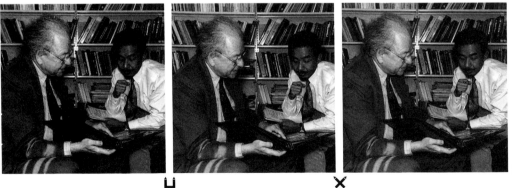

Figure 2

it might have otherwise. You see, for a young unknown scientist, it is nice to have a powerful patron. It is actually even better to have a powerful, famous rival. Of course, in that case, the young man has to be right.

The scientific controversy between the stereopsis authority and myself may have drawn people's attention to my findings.

Shimojo: You are also well-known as a master of aphorism, maxim, and stories. I have heard that your favorite is a story about two frogs or something?

Julesz: Yes. There were two frogs, and they fell into a milk jar. The pessimistic frog realized that there was no way to stop his body from sinking. He then closed his eyes and sank. The optimistic frog, on the other hand, did not know anything but kept moving his arms and legs, struggling against the milk. It was solidified and eventually became butter, so this frog was saved.

Shimojo: Is this story also your original?

Julesz: No. My father told it to me all the time. He was a lawyer who suffered with us severely during World War II. He was an excellent man with lots of optimism.

Even a genius has some dark sides in his personal history. In Julesz's case, the turbulent years of his youth and his own experience as a refugee from Hungary should be counted as such. But instead of asking about those, I would like to concentrate rather on his research life.

Shimojo: A little more about your work after the random-dot stereogram. You later proposed the grand theory of "texton," which was a counterpart of the "photon" theory in visual perception. As far as I understood, it was a grandiose idea attempting to specify "tokens," or the elements of visual perception in general. This framework conceptually includes the ran-

dom-dot stereogram as a special case, you used to say.

Julesz: That's right. The texton theory is essentially about early vision, or "preattentive" processes. That is, about the effortless aspect of visual perception where the observer does not have to scrutinize to see things pop out.

It would be wonderful
if we could expand the outdoor space
by the stereogram, and let people share it.

Compared to my intellectual efforts and high motivation for this theory, the random-dot stereogram was nothing. The stereogram was just that I thought it ought to be possible, and it turned out to be possible.

As you may know, this theory has not been accepted as enthusiastically as the random-dot stereogram. In my latest book (*Dialogue on Perception*, MIT Press: 1994), which is a kind of autobiography but in a dialogical style, I took both the roles of author and devil's advocate. I repeatedly raised skepticism about my research career and struggled to answer it because that's exactly what I have been doing in the last several years.

Some of the questions that Hilbert had raised turned out to be undecidable. Perhaps some of my questions are undecidable, too. Yet, I still think that the general theoretical direction has been approved, and its influence in the field has not been negligible.

Whenever I wonder how much of my theory has been known to ordinary people, however, I always think of one of my favorite composers, Ravel. His best-known piece is "Bolero," as everybody acknowledges, and owing to it he left his name in history. From his viewpoint, however, this was just a small one among better creations. Because he wrote so many forgotten, yet inspiring, great pieces.

I was overwhelmed by the professor's everlasting passion and obsession about his research. To me, he appeared as though he were a genius home-run batter, who once hit a home run out of the park. He still tries at bat next time, even though there is no guarantee that it is going to be another big one. Enthusiastic fans would even think he should not try again so soon. But he himself does not hesitate for a moment to be at bat again. It is not that he has no fear of failure, I assume. It is just that his passion overcomes.

Shimojo: It might be too early to evaluate the invisible influence of the texton theory. Finally, please tell us about your dreams. By that, I mean your yet-unrealized dreams with random-dot stereograms.

Julesz: There are two dreams in my mind of which I have conceived for a long time but have not been able to realize. One is to bring (random-dot stereograms) into a more environmental usage. It would be wonderful if we could expand the outdoor space by the stereogram, and let people share it. For example, we may be able to draw a Klein bottle (the bottle whose inside space is continuously connected to the outside space) on a skyscraper's wall by the random-dot stereogram, particularly with the glassless technique. Of course, how to wash it would be a serious problem, I guess.

The other dream of mine is to develop a tactile version of the random-dot stereogram, a stereogram that blind people could experience. I do not have any clue of how to do it.

When the interview was over, Julesz posed for stereo photography in a very good mood. We then went to a nearby Chinese restaurant for lunch, where he told some glorious stories of the Bell Telephone Laboratory with legendary names.

ARTISTS' PROFILES

DAVID BURDER
British-based multimedia 3-D artist. Works in a wide variety of media, including anaglyphs, film, and holographs. Holder of numerous patents. Currently serving as president of the Stereoscopic Society.

KAN DAVA
Born 1956. Graduated from Osaka Art College. Working as a freelance advertising illustrator. Switched to 3-D computer stereograms after ten years of creating hand-drawn illustrations.

MAYUMI DAVA
Born 1958. Graduate of the Department of Design of the Tama College of Art. Freelance illustrator. Holds an interest in computer graphics, stereoscopy, and computer telecommunications. Goes by the handle "Yumehime" (Dreaming Princess).

DIN
Two-man art team formed in 1990 by Eff Ludecki (born in Germany in 1964) and Michael Frank (born in England in 1966). The graphic arts unit of Himmlischer Asphalt, a contemporary art group also formed in 1990.

HISASHI EGUCHI
Born 1956. Popular Japanese comic artist known for his unique humor and character designs.

IZURU FUJITA
Born 1965. Systems engineer. When asked to design a wallpaper design, he created a program by studying a single-image R.D.S. Has also created R.D.S. animations.

KATSUHIKO HIBINO
Born 1958. While a graduate student at the Tokyo College of Art, he was a Grand Prix winner at both the Japan Graphics Show and the Japan Illustration Show. *Katsuhiko Hibino*, a book of his work, has been published by Shogakukan.

HISASHI HOUDA
Born 1955. Graduated from the Department of Sculpture of Aichi Prefectural University of Fine Arts and Music, Japan. Formerly worked in special effects production, now a freelance multimedia designer and programmer.

HAL IIDA
Born 1952. Has been active as an artist since 1971; started working in computer graphics in

1991. Author of *Universo*, a children's stereogram picture book (published by Shogakukan).

MIYUKI KATO
Admirer of American illustrator Maxfield Parrish since her design school days. Currently working as a researcher of computer user interfaces.

NAOYUKI KATO
Born 1952. Illustrator specializing in science fiction and fantasy. First experienced unaided stereoscopic vision at age 12. Encountered the wallpaper stereogram technique at age 40.

YOSHITAKA KOKUBUN
Born 1962. Works as a creative director on digital design and prepress.

HIROSHI KUNOH
Born 1948. Graduate of the Tokyo School of Photography and Konan University. Longtime commercial photography manager. Began developing stereograms using photographs in 1993.

MICHIRU MINAGAWA
Graduated in 1984 from Tsukuba University, Japan. Began her career as an illustrator and coordinator specializing in medicine. Joined the Meta Corporation in 1988, where she supervises the Human Body Database.

SHIRO NAKAYAMA
Born 1956. Graduate of the Department of Mathematics in the School of Science of Hokkaido University, Japan. Director of Software Development at Sapiens Co., Ltd. In the summer of 1992, developed a technique for producing smoothly curving stereographic surfaces.

MASAYOSHI OBATA
Born 1966. Finished graduate studies at Musashino College of Art. Currently a member of NHK Enterprise CG (Computer Graphics) Room. Worked on computer graphics for many TV shows and commercials.

JUN OI
Born 1950. Production Chief of Admax Inc., one of the pioneering computer graphics production groups. Author of *A Collection of High Tech Patterns and Hyper Grafix*, Vols. 1 and 2.

SHINSUKE SHIMOJO
Born 1955. Former MIT researcher. Completed graduate studies at Tokyo University, where he currently teaches perceptual psychology as an Assistant Professor. Author of *The Birth of Gaze*.

KENNETH SNELSON
Born 1927 in Pendleton, Oregon. Highly acclaimed modern sculptor with exhibitions and collections all over the world. Recipient of numerous awards in the U.S. and Europe. His modern stereo pairs are another form of expression for this accomplished artist.

TATSUHIKO SUGIMOTO
Born 1968. Computer graphics illustrator and former Japan University student. Since working for Magic Box, has been involved in a YMO (Yellow Magic Orchestra) laser disc, and various commercials.

MAKOTO SUGIYAMA
Born 1935. Graduate of Chiba University working on a "still image" system since 1975. Currently creating computer graphics using HyperPaint.

EIJI TAKAOKI
Born 1951. Graduated in 1979 from Osaka University, Japan. Studied computers in the Engineering Department in 1986. Developer of the famous software package, "MetaBall."

TAKASHI TANIAI
Born 1962. Worked as a fashion knit designer for Kansai Yamamoto. Currently manager of Batron Creative Inc. His 3-D art book, *Dino-Roman*, includes the images presented here.

KENGO TSUKASAKI
Born 1951. Graduated Musashino College of Art, now working as a digital illustrator. Began using a computer after developing fortunetelling software. Currently trying to express *I Ching* in 3-D.

TADANORI YOKOO
Born 1936. In 1972, the New York Museum of Modern Art conducted an exhibition of his work. The recipient of many awards and subject of many exhibitions, his graphic art has been collected in *The Complete Tadanori Yokoo*.

SEIJI YOSHIMOTO
Creates realistically detailed 3-D computer graphics based on his childhood dreams and wishes. He heads a department in NEC that deals with communications satellite development.

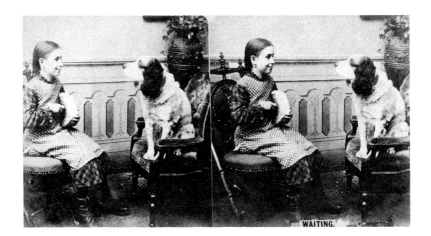

Girl and Dog
(Photographer unknown; late nineteenth century.)